You're A Snarky Darkness

illustrated poems for radical empowerment

Sage Liskey

Table of Contents

*Illustrated

Introduction

It's nearing the end of 2020 and my what a year it's been. I moved from outside a porn store into an old firehouse and then a purple mansion, thought my home might burn down, ended a relationship, and after three to a million years of work, depending on how you look at it, released *You Are A Great And Powerful Wizard: Self-Care Magic for Modern Mortals*. As difficult as this year of pandemic has been, there's also been a lot of hope, support, and love. I believe in you, and I believe in me too. We can get through the most difficult times if only we remember to work together.

You're A Snarky Darkness is a collection of the past six years of my poetry, including two poetry zines I released titled *Wine And Poetry Night Year One* and *Poems For The End Of The World*. I had written some poetry when I was younger but eventually stopped for other artistic adventures and distractions. It wasn't until some lovely people from Colorado brought with them a private poetry gathering known as *Wine And Poetry Night* that I began writing passages of broken English again. When they eventually moved away, I took it upon myself to continue this grand event that united many friends, lovers, and ears needing a cathartic burst of goodness. As I only write poems if I have a private event to perform at, it goes without saying that none of this would have been written without those fine souls and the several home venues that hosted us.

If you find my words dandy or nice, meaningful or impactful, I'd love to hear from you. I promise I'm not scary, I really enjoy meeting new people and it would mean the world to me to know what you think (connecting with others is the main thing that keeps me writing and creating). You can also leave a review on Good Reads, Amazon, or Etsy – that helps me a lot and makes me feel great inside my tender little heart. Send me an e-mail at radcatpress@gmail.com or find me on Instagram or Facebook by searching RadCatPress.

The illustrations contained herein are digital collages made using public domain images, Photoshop, many hours of screwing around, and a lifetime of being odd. Please note that the hardcover version of *You're A Snarky Darkness* is printed in full color and available through my Etsy store. Alternatively you can see the colored images on my website <www.sageliskey.com>. Also on my website you can hear audio recordings of these poems and read my many words on uplifting your life, coping with depression, and reimagining society. Instagram however is where you'll find most of my newest content <www.instagram.com/sage.liskey>.

If you'd like to support my work further and get some special perks, consider subscribing to my Patreon at <www.patreon.com/sageliskey>. You can also order signed copies of my books directly from me at <www.etsy.com/shop/radcatpress>. I might sometimes have art for sale there too.

Without further ado, I hope you enjoy this collection of snarky darkness.

2014 – 2015

Wine And Poetry Night Year One

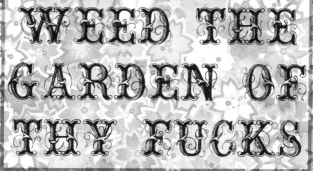

WEED THE GARDEN OF THY FUCKS

Do You See Any Fucks Growing In My Garden?

Today, I took my little shovel
and ever so carefully
weeded my garden of every
single
last
little
fuck.

I started by stabbing deeply into the mind,
loosening the roots of that fuck
that grew like hot jealousy in late summer.

Fuck fact:
Fucks spread
through root,
seed,
and invisibility.
Fact.

Then I stabbed again
the other side of that fuck
growing like
frigid death
in mid winter.

Fuck fact:
Fucks grow fast.
They take over your garden.
You must weed them out before
they eat you alive.
Fact.

I exposed the roots with my hands,
finding that fuck from early spring
who looked almost innocent.

Fuck fact:
When a fuck
takes you over
you spread fucks
to other gardens
and become a fucker.
Fact.

And then I grabbed hold of the whole fuck,
a scared demon in the fall,
It screamed no as I pulled
and I threw that fuck in the fire
before it could grab hold.

Now do you see any fucks in my garden?
None, I'm growing a crop of petunias this year,
and I just don't give a fuck.

Dear Couch

After a long hard day
dare say I
your embrace is like a hug
on all the drugs

Cat Power

Purr at it; buildings will shake.
Meow at it; victory is in sight.
Put a cat on it; empires will crumble.

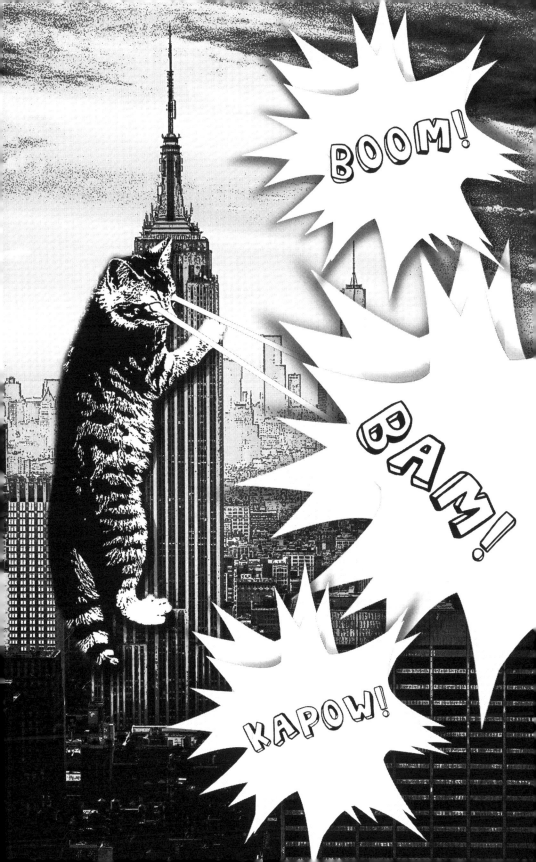

Don't Fuck With Me

I'm sitting here organizing,
rearranging neurons,
dusting out the cells,
synthesizing atoms,
colliding protons,

So don't fuck around with me,
okay?

If I wanted to
I could see magic on charred toast,
gods in the toilet,
and demons on your nose,

But today,
no one's going to fuck
around with me.

Fate, I know that you're just trying
to make me fall in love
or kill me,
but aren't we past this?
Can't we just be friends?

When there's a phone
lying on the ground,
or a key falls out of a box,
or a bird shits on my head,
oh I know what you're getting at.
Calling me to see something deeper.
Calling me to sway with the winds.
Calling me to be fucked with.

Fate,
I'm holding you tenderly.
And sometimes I'll listen to
and sometimes I'll follow
your every weird word,

But today,
I'm going to tell you what to do:
Fuck off, I'm busy.

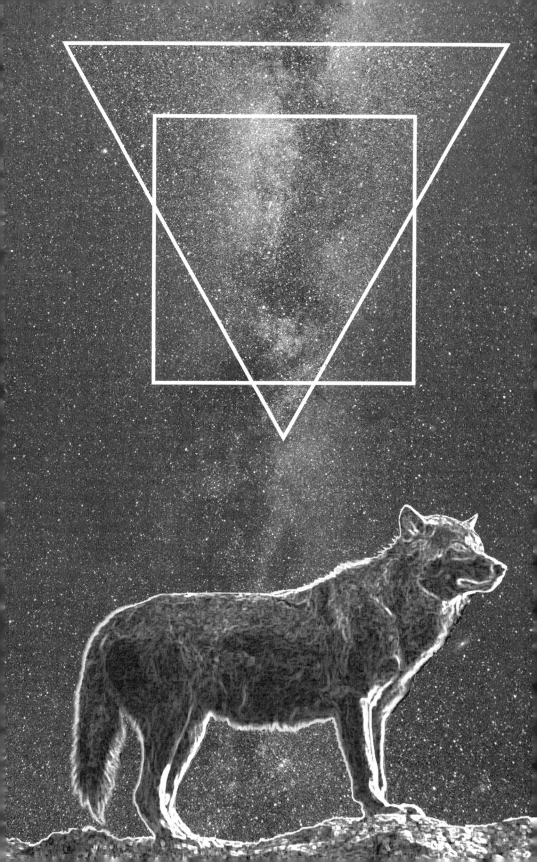

Wolf House

The wolves are asleep.
Lying all around
my mind my body my soul my house.
The wolves are always asleep.
That is until someone treads louder than a mouse
into my body my mind my soul my house.
And these wolves, they are hungry;
willing to eat anything,
willing to eat the mind the body the soul,
willing to eat a whole house.

So I sit here
waiting
attempting patiently
for someone
for a mind a body a soul a house
to come inside quieter than a mouse.

But I'm sorry I haven't made it easy.
There are boxes piled against the door
and I hardly open the curtains anymore.

And the wolves.

But you must understand
they are the only ones to keep me company
over the cold cold nights and these long long years.
And what then if they are gone? Will you stay?

It is a delicate matter.

So I sit here
sometimes thinking

if that mind that body that soul that house
were the better of these wolves,
an ax, a shotgun, and a shovel
might do finer than a mouse,
raising hell just once to bury these wolves
outside this house.
But be sure with an aim of rage,
because a mark off and
I will go astray.

And these days I might look
a little wolf myself.
So don't be confused and surely do not lose.
As I sit here
waiting
attempting, not so patiently
for someone,
for a mind a body a soul a house.

Smell Memory

This air is intoxicated
with memories,
it's like things go
up my nose
and a
camera reel begins
to turn;

Coffee
and mornings as a child.

Warm bread
and the dumpster of baguettes.

Fish sauce
and my ex's cunt.

I smell memories.

I Am Fiction I Am Dream

I am fiction I am dream.
Inspired from the triumph
of heroes and villains

Hear me:

I have seen gods
and through which jealousy sparked
an aspiration into their glorious steps

To become a god
and seek only what is unseekable.

But then I realize how gods aren't revered.
Gods are things to be fearful of
holding life and death,
happiness and eternal woe
in flux

And so now with a cleaver of contradiction
too great for the lie of perfection to defend against
I dethrone gods
by ripping away the masks
which hide their souls

You see
I was once baffled by beauty
to the extent
of being stabbed by
a red searing blush

Well I am no longer afraid of beauty
or even life itself

I am here
I am now
I am inspired

Within the gaze of a shooting star
I will crash
I will burn
I will regrow
in imperfect perfection
and realize new intricacies
within this fiction
within this dream

Friend

Hey,
hey you,

You despicable, ugly
and pathetic
mother fucking
gross piece of
washed up,
worthless,
atrocious,
no-good,
lazy,
fucked up,
stupid,
awkward,
shit on a stick
dipped in a pile
of rotten
skunk vomit

You're just like me,
aren't you?

Let's be friends!

Cocoon

I'm going to
wrap myself
into a cocoon
and pop out
as the biggest
brightest flower.

Child Of Light

Child of Light
you rode faster
than the moon

Outran her cycles
and they became untrue

Split off from rationale
and made love
to the lush forests
deep underground

Mama's worried.
I just don't know
what to do.

Child of Light
I can almost see
you're becoming
something so new,
but don't you
miss the moon?

Mama's worried.
I just don't know
what to do.

Look, I'll take
you back to the moon.

I'll find the forests
deep underground.

Wouldn't you be
happier there?

But mama wouldn't
have none of that,

said she wasn't ready,
said you weren't ready

Sent down a hurricane
to swoop you away.

You can't outrun this.
There won't be
nothing left

Except my
memories of
the possibilities
of you.

Idea Thread

And then a
whirling and twirling
idea smacked me
in the face.

I'm pulling a long black thread;

I imagine at the end
is a pink flamingo
that will grant me
one wish.

I imagine at the end
is beauty still upset
at itself for a day
that ended too soon.

I imagine at the end
is the end
and that's all.

The whirling and twirling
went away.

I forgot about the thread that was now
a tangled heap
at my feet.

And here we are again.

It Might Just Happen

You might get a fish in your pants
if you use the ocean as a blanket.

Aren't you worried?
Aren't you afraid?
It might just happen!

You might get a bear caught in your hair
if you use the forest like a beauty salon.

Aren't you worried?
Aren't you afraid?
It might just happen!

You might get a wingnut in your house
if you use the city at all.

Aren't you worried?
Aren't you afraid?
It might just happen!

You Are A Great Wizard!

Poof!
Puff!
Pablamy!
You are a great wizard!

You need only say 'wing wam soot toot'
around a gaggle of children
to prove your power potent.

Showered with giggles
for hours on end.
Your magic is fantastic.

Poof!
Puff!
Pablamy!
You are a great wizard!

You need only
smile briefly at a stranger
to prove your power potent.

Passing your joy
from person to person
your magic is fabulous.

Poof!
Puff!
Pablamy!
You are a great wizard!

You need only
follow your heart

to prove your power potent
Living each moment
presently powerful
your magic is everywhere.

Poof!
Puff!
Pablamy!
You are a great wizard!

Be proud
for you have powers none other do

Be brave
for just the right spell
will open that sealed door

And be wise
for the wrong magic
might just end it all.

You are a great wizard.
Poof
Puff
Pablamy

Sand

I was
chewing on
grains of sand.

Golden Ticket

I found
a beautiful
golden ticket,

it is a first class
ticket,

to get the fuck
away from you.

Dig Chop

There are demons
surrounding me,
so all I can do
is start digging
a hole and
chop wood
underground.

You Are An Excellent Architect

You are an excellent architect.

You've taken each broken relationship,
and mortared them together
into a perfect wall
around your heart.

You've wired together
a beautiful fence of neurons
to keep in the beasts of hate
and out the lore of love.

You've built a special mechanism,
a twitch in your muscles,
to show how
disinterested you are.

And you dug a trench
to deepen the pitch
of your voice just enough
to sound like a sociopath.

You are an excellent architect.

Sweep Sweep Sweep

You go outside
underneath the stars to
silently sweep away
every brilliant color
of the rainbow that ever
found itself at your doorstep.
Dilapidated. Methodical.

Sweep sweep sweep

You remember
a warm hand
embracing the unworthy flesh
on your fingers.
It felt as if a small sun
had blossomed in that
space between and warmed
the whole neighborhood.

Sweep sweep sweep

You remember
the thin line between a
demon and trust.
This match for fire
that metal for blood
a word for safety.

Sweep sweep sweep

You remember
laying cozily underneath
soft sheets, moving

oh so quietly to
keep her dream alive.

A mossy forest
in a bowl,
sewn up strands
of fabric,
and so many little
animal bones.

Sweep sweep sweep

You remember
mother fucking
sweep sweep sweep
and are glad that broom
isn't perfect while
looking up at the stars.

Sweep sweep sweep

2015 - 2017

Poems For The End Of The World

Trick of the Eyes

You just do until you feel awake,
forget you are sleeping.
You aren't actually awake,
yet
all distractions
point you away
from that subtle truth.

Consumption

Today I had a bad day
so diligently ate
each morsel of food
on Earth.

But this made me feel no better,

so I could not help
but drink all
of the ocean's water,

burn every
tree down to
black charcoal,

breathe in
every last bit of air remaining,

and consume planet after planet,
along with the stars,
galaxies,
and gods.

Upon finishing my meal of the universe,
I collapse into indigestion,
and feel terrible.

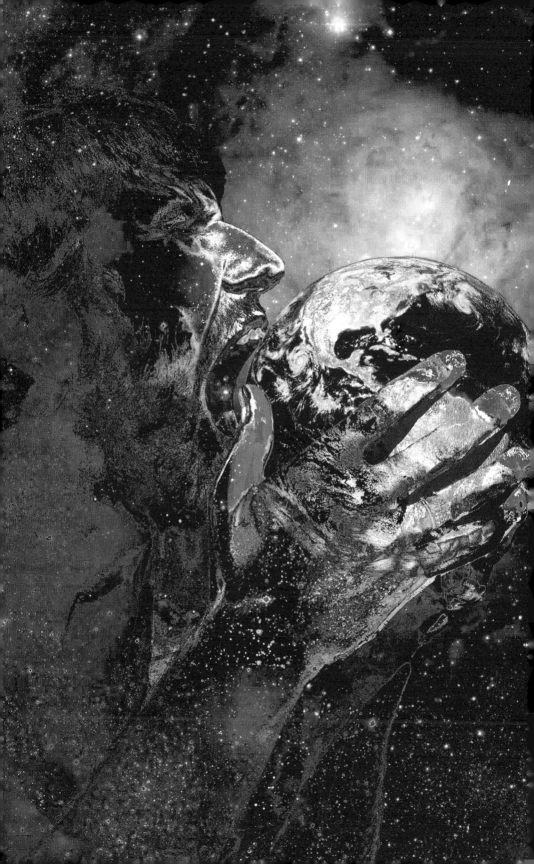

Friends

I need to remind myself that there are friends,
there are FRIENDS,
there are "friends,"
there are friends...
there are frieeeeeends!
there are frrrriiiiends,
there are mmmm friends,
there are ummmm friends,
there are friends,
and then there are stupid piece of shit lousy fucked up
friends.

Road

I questioned the existence of the road thoroughly.
Rocks, pebbles, pot holes, ditches, tires, imprints,
perhaps a deer.
The road moves in curves and mysterious lines.
I am moving the same way the road moves and perhaps I am the road.

Lies

You can either
lie yourself into joy
or you can
lie yourself into suffering.

The choice is yours.

In Watermelon Sugar

The regrettable sigh I release is
deeper
than all of the farmer's
dry wells.

You see,
I'd rather not talk about the moon today
because those tiger eyes light up like fireflies,
like blood is life
and you're not here to teach me arithmetic
but tear this fragile adulthood to mincemeat pieces.

It is morning,
I am ready.

Dehumanized

Business dehumanized me.
In the crinkled folds of another business report.
In the emotional void of another sale.
In the...

No, heartbreak dehumanized me.
In the losing streak of vulnerability.
In the un-tuned love chords playing rubbish.

No, capitalism dehumanized me.
In the hours spent accomplishing nothing.
In the vampiric exchange of blood for money.

No, fear,
fear dehumanized me.
In the tingling darkness scattered with knives.
In the thought of action thoroughly destroying action.

No,
I know what did it,
it was the rats
who dehumanized me.

The Problem

Love is:
→ connection
→ vulnerability
→ presence

Capitalism is:
→ the problem

Memory

There was a memory from yesterday
moving so fast in the darkness behind us
being swallowed
and no trace that
the light ever existed.

Trust.
There was trust.

Movement

Perhaps consider that life
began as
small repetitive motions,

a dance in the primordial seas.

And wishing to dance a greater dance,
life grew
and learned to move in union,

into bacteria, fish, rabbits, wolves, elephants.
Into us.

But the dance did not stop there,

we howled together at the moon,
sang songs around the fire,
and celebrated the givings of Earth.

And before we knew it
were a new form of life.

We grew into greater beings
as the trees intermingle into forests,
the birds fly in flocks,
the morning mist collects into clouds,
the planets revolve into solar systems,
and the galaxies swirl into the growing universe,

we dance into our
organism that is community.

And it is our duty

to keep life's momentum growing:

To move
so the great beast may move.
To dance
so the great beast may dance,
To love
so the great beast may love.

Civilization's Forests

Most of civilization
is contained within
sprawling monuments to humanity,
but those people
will never know the ghosts
of great trees they step through.

Bookstores

When you walk
out of the bookstore,
you wonder if
you left part
of yourself behind,
trapped between the
pages and spaces of
words,
punctuation,
dreams.

Good Morning

Reading the signs
of the morning magic rooster,

a cockle-doodle-do.

The door slams and
all the music is replaced by
ocean waves and deep sighs

In and out.
In and out.
In and out.

They say there is a whale
living in these waters
that the land dwellers
point exclamations at.

Over the bridge,
as the whale passes
under the bridge.

I am here,
I am walking up the hill,
I am gone.

Hope

I find little
pieces of hope
hidden
under rocks and
in between cracks
as the universe
screams at me.

Thought

Maybe
that is it,
you are the mysterious god
and I am the periodic occurrence.

Bone's Word

There is a word
hidden in my bones.
I must snap each two hundred and six apart
to spell it out.

The first is excruciating.
The second uncomfortable.
The third tickles.
The thirteenth feels like biting into toast.
The twenty-seventh has the crunch of cereal.
The fifty-first is a memory of heartbreak on a cold day.
The seventy-eighth might be a clue.
The ninety-ninth dreamed of sunflowers.
The one-hundred and thirty-sixth resembles a powerful queen.
The one-hundred and eighty-ninth is where I stored my childhood.
The two-hundredth feels like a really great accomplishment.
The two-hundredth and third is hard to remember.

On two-hundred and six my body is a crunchy jelly
as I read the word:
_____ (Love).

There Are A Lot Of Things
I Wish I Were Doing

There are a lot of things I wish I were doing,
like howling at the full moon,
or falling in love with you.

But I have to take my medicine.
It is necessary and bitter
alone with Father Time
at the forest's first sprout of life.

Better Start Digging

Those unsaid words buried deep below.
If we can only dig
through these layers of
malice, ego, and regret,
maybe then the ores will be refined:

The gold will gleam,
the silver will shine,
the rubies will ring until
"I'm sorry" stands
"I love you" leaps
and "thank you" transcends what has passed.

We had better start digging.

A Gang of Silence

What if the sound from all you loved went silent?
How can a silence become deeper than quiet?
Only if the mouths of many SHUT with a violence.

The Gang has spoken,
an orchestrated pause to the music of life,
the heart beat will fade at a rate unknown to science.

Won't the sound please come back with a loving vengeance?

Wrinkles

She said,
"wrinkles are formed
so the blood
doesn't
drip
into
your
eyes."

I Want You

I want connection,

The sort of connection
that weaves bridges
between mind body soul spirit.

I want to know you
intimately underneath
the veils of scars
of chores
of adult bullshit
and share a drink from the
chalice of who you really are.

I want to fall asleep and
meet you in our dream,
to speak in tangible
tones of music and
share a moment with your
best friend,
the ghost of a meteorite
who met the meaning of life
at strides with stars.

I want you to continue
loving everyone and everything
around you as much as you love
the steam rising from a cup of tea,
the first sprouts of Spring,
the cracks in paved cement that prove
change comes at variable speed.

And when someone

pulls the trigger,
the guillotine falls,
the siren blares,
the silence ensues,

When the end is coming soon,

I want for us to smile.

Rock Bottom

The goal
is not
to hit rock bottom gracefully
so that you can
crawl back out again to your old self;
the goal
is to
hit rock bottom so hard
you explode through
to the other side in fiery glory,
to your new life.

Split

To _____

I have a question...
Do you exist?
Because I feel that at any moment you might disappear,
leaving no trace that you were ever here at all.

It's as if you are a shadow,
midnight burned to daylight's jagged surface.
Holding you I hold a ghost,
like someone stole you away,
young, innocent.

I love what I think exists
in those moments between
waking up to see you peacefully asleep,
in that five string harmony of an orgasm,
in the small details concerned only
with the biggest brightest smile.

But then I wonder why,
your moon is but a shadow of the sun in its past
and the whistle from your bellows holds no church.

Did you find enlightenment?
A vessel for gods above?
The beginning of the end?
The end of the beginning?

I don't think so.
You are merely a glass jar,
and the only way I can fill you up
is by emptying myself out.

I hope that by my leaving,
our bodies separating
our minds untangling,
that you find an inspiration
in the energy of an atom splitting
or an egg cracking,
something wholesome
powerful
substantial
beneath the layers of strands we wove together

An explosion of existence.

The likelihood of us being rejoined is
improbable to say the least, but
I believe
in your capacity
to create
a whole new universe.

Goodbye,

Signed _____

Staring Into The Eyes Of Robots

I leave it on
so I can burn
a small hole
in my mind.

The
iridescent glow
follows me,
a needle stuck
into my eye,
dripping light
and color out,
painting the imagination
and past
into blurry vignettes
on brick walls,
rain drops,
and passing strangers.

Robot

I've been mingling with robots
my whole life,
whispering into their ears,
they into mine.

A giant mechanical beast rolls by.
Who are you? I whisper.

You.

Hands

Put your hands side by side:
they are entirely different,
touched different things
had different experiences
loved differently,
but they compliment each other.
Together they are your hands.

Cyclic Thoughts

Like the explosion of flowers in spring,
or cozy discovery of blankets in winter,
or the faithful leap into the cool water of summer,
or bountiful harvest of fall.

These are some of the things to think about
while dying and being reborn.

Dream Leaf

In the morning I find
a leaf in my bed.

It must have slipped
out of my dreams
as I walked
through the forest
of stout turquoise trees
and green goldfish.

I Did Not Start A War This Year

I did not start a war this year.

I did not attempt to save my old crumbling home,
tear apart that illogical hypocrisy
or make a single poster to raise eyebrows.

I did not start a war this year.

I did not save the country from tyrants,
tell that woman what a piece of shit she is,
or say that I love you dearly.

I did not cry foul to bad science,
bad spirituality,
or bad food.

I did not start a war this year.

I did not throw the cat off my lap,
drown the rat,
or catch a single shimmering fish.

I did not tell the people what I think of them,
tell myself what I think of me,
or expose the truth about you.

I did not start a war this year.

Not a drop of blood,
broken bone,
argument,
or arson.
I kept silent,

I stayed alone,
and I maintained peace.

I did not start a war this year,
and I will always regret it.

Living Hope

Everything appears dead
but
there are
signs of
life returning.

I like that time.

I Remember The Golden Empire Well

I remember the Golden Empire well,

in the catacombs locked doors of rusty robots and
such obscure treasures coldly inlaid with gears and fine threads.

Up the stairs,

the main hall connected kitchen and cozy couch to
lazily fill the belly with a laugh
through the vortexes of late night.

Up the stairs,

the first living quarters was inhabited by a whale watching
sleepy demigods experiment with
strange powders and sexual desires.

Up the stairs ,

the second floor of beds championed the eyes of a unicorn
leading straight into the helm of the ocean
which listened to the most secret of stories.

Up the stairs,

the attic spoke of ghosts
but the tower's peak pervaded a musty darkness
well met with glowing fireflies bedazzling quiet eyes.

Up the stairs,

the rooftop precariously overlooked the whole city into sunset and
lighting of bedrooms come night,
let us sing to our roots.

I remember the Golden Empire well.

Down the stairs,

the bloodstained wars with rats.
She slipped in the poison
for health.

Down the stairs,

the woman hung herself here,
with a rope,
with a sadness.

Down the stairs,

the angry messengers
so kind until the suits of Mars visit
to light the fuse.

Down the stairs,

the Kitchen Witch
rearranging jars and scrubbing with a glare,
singing her despair.

Down the stairs,

the lying lazy man
vying for power in a thick darkness
cackling into the crumbling cracks.

I remember the Golden Empire well,
and I remember its demise.

Gardens of the Old

Prune the roses,
water the petunias,
rake the leaves.

The old pay me a million
dollars an hour
to hide death from them.

Just as they hide
their mirrors
and wrinkles

they instruct me:
not a wilted lilac,
brown patch of grass,
nor frayed branch.
I use my hands and machines
to round up the bodies,
cut off the heads,
rip apart the limbs,
and drag them all away

to burn,
to tuck in the corners,
to clean any stains,

but death
always
comes back.

And isn't it funny?
The other day
I saw flowers and trees and life

sprouting from last year's decay.

I smirk
as the old pay me
a million dollars an hour
to hide death from them.

2017 – 2020

You're A Snarky Darkness

Icarus

The sun is my love
and I fly with joy toward the light,
hoping my wings can withstand
the heat of your heart.

But even if I fall again to the featherless ocean,
flying is my right,
and I'll find a way to be with you sun.

Yes this time, surely, I will stay with the light.

Winter Gave Me

Winter gave me
a lot of shit
to grow flowers with
in spring.

Affirming Steps

Step 1) Give a shit.
Step 2) Give fewer shits.
Step 3) Reassess.
Step 4) Give no fucks.
Step 5) Give many fucks.
Step 6) Reassess.
Step 7) Reaffirm giving no fucks.

Fallen

The more gods you meet,
the more you see fall from grace,
forget their magic and
flail in being merely human.

It's a sad sight.

Reality

You peer through
culture,
emotions,
memories.

You peer through
television screens,
window panes,
sun shades.

You peer through
your eyes.

If you always look through something,
at what point do you see reality clearly?

Mind Miner

Please, I'm sorry,
I am a miner in the deep caverns of the mind.
There is only so far I can take you before
the darkness becomes dangerous and
you must stay behind in the light
with the beacons of being alive.

You see, the jewels I keep beyond here
are only for those once graced with death's dear
desire to die in the dark.

They are beautiful,
but don't come any further,
turn back to your joys in the jewels of light.

Out Of The Way

Everyone was getting out of the way for you to arrive,
bowing their heads to their queen,
giving space for you and I.

Sure I Would Love To

Sure I would love to
feel you up, and
cuddle you,
kiss you,
fuck you,
but I sure don't think
we'd like each other
afterward.

I Am Repairing A Robot

I am repairing a robot
the wasps and moss
took over:

"shooo, shoo, shoo!"

You are shiny and mine.

In The Guillotines Of Time

I am vividly aware
of my death,
my soul,
my connection to the cosmos
as stardust now on Earth.

Any moment it may happen,
this body may shatter,
the blood spill,
the wrinkles corrode,
the organs fail,

and I will become what I am already.

Time Traveler Love

Being in love
with a time traveler
is difficult,
chasing her shadow
through the ticktock
of the clock

like a bat flying fast
in a sky dimly lit with stars.

Holding onto that twirl
of red thread,
we're still
somehow
connected,

and I whisper
every great while
when the ends
whirl together in the wind,
"I love you,
I love you,
I love you."

I Want Beauty

I want beauty but
I live in an ugly country
in an ugly city
in an ugly house
in an ugly room
in an ugly body
in an ugly mind
that refuses to see the beauty all around.

When Things Are Going Bad

It's relieving to hear that
you are suffering too.

Sometime In April

I stopped
trying
as
hard.

Temporarily

I discovered that
there is hope where you
least expect it,

temporarily

until just as you
think the golden chalice
is yours,
it
turns out being
aloof and
too preoccupied
with
saving the fairy kingdom.

And respite returns to
hopelessness

temporarily,

until remembering
a sense of security in
that the government still
knows everything
about you.

This gives you great relief.

You Are A Great And Powerful Wizard

Poof puff pablamy!
You are a
wonderful,
fantastical,
whimsical,
magical,
and powerful
wizard of wise ways

I see it,
I know it,
I deem it true!

here are some tasty and tantalizing
spells that you can take on your tall travels,
so please potently do.

Zip zang zippidy-zo!
I'd first like to tell you about
a thought that you can sow

thinking
I love
me,
you,
the world too.
I love
me,
you,
the world too,
I love
me,
you,
the world too.

I see it,

I know it,
I deem it true!

Blurgle-lurgle, hurgle-murgle!
Movements make masters of
magicians,

dancing daintily then dangerously,
smile stupendously
to share serenity.

I see it,
I know it,
I deem it true!

Fru fo fibbity fab!
Feelings free folk from
fallen futures,

loving, crying, sighing, shouting,
emoting energies to
open honesty.

I see it,
I know it,
I deem it true!

Sakka takka la wakka!
Words weave wondrous webs
with weathered wisdom.

Read aloud
remembered memories cast in
ink labeled
stories, adventures, fantasies, mysteries
containing the etymology and histories
of the poof puff pablamy!

You are a
wonderful,
fantastical,
whimsical,
magical,
and powerful
wizard of wise ways.

I see it,
I know it,
I deem it true!

Some Slivers

Some slivers
you must
dig out
with a
knife.

The Joy Of Being Alive

The lions wanted me to meet you,
coordinated through a three step funky waltz on time
before
mercilessly
ripping out
every
atom of ego.

You didn't make a sound,
but I could hear your scream louder than
a murder of a million crows cawing;

Why would you live for anything but
the joy of being alive?

You have a point.

Held Close

Being held close helps
sometimes.

Being held
horizontally,
undressed,
while making out
for a really long time
helps more.

I Felt Fleeting

I felt fleeting
in search of
that word,
tasted like a memory,
smelled of the moon,
looked like mother.

Only You And I

Only you and I
will remember the
sex drugs and sadness
down by a year of time.

The dog is going to die.

I Like Being Here

I like being here
above the roaring river;
you cannot hear the robots
and their rip roaring revving
beep boops.
All that's left is that memory of you
and an awkward bottle of honey whiskey watching sunset shimmers;
you always have to wonder what those rocks feel like.

The robots whisper,
the bottle dry,
the sunset faded,
demigods die too.

It's Friday Night

It's Friday night
and I can't overcome
the fear
of going back in time,
so I stay right here,
drinking my wine.

Now I Am A Wolf

We ran together like a pack of blood soaked wolves.
Yeah,
once upon a time
we drank gold from ruby goblets,
bathed in the celestial glow of starlight,
spoke poetry to black holes.
Yeah,
we were bad asses,
the coolest shit in the universe,
and now we aren't.
That thing that sometimes happens,
it happened.
And now I am a wolf.

Her Twin's Eyes

Her twin's eyes have faded,
stolen by the promises of a robot machine
looking for safe truths;
burned images of somewhere
to nowhere behind the retina.

An eerie exchange,
I wonder what she's looking at
when she looks at me?
Perhaps
dragonflies in summer,
the meaning of the letter Z,
molecules of water,
knowing with certainty that the dog is going to die;
she never even saw me.

Heart Thump

Heart thump
the thump split
split wood on rocks
giant rocks at the ocean
the ocean is moving with the moon
moon magic
I wanted to say a magic word
but that word is lackluster
it grows lackluster lavender
all I want is to smell lavender fields in Summer
the Summer is still Winter
Winter provides ample opportunities
opportunities are squahsable
squashable like heart thumps.

I Remember

I remember
the hot crush
of red red red
lipstick
on a burning flag
a teacup at
a time
too late,

and all
I can wonder now
is if
you're dead.

It's A Good Thing

It's a good thing that time exists for
all you on the tick-tock of clocks,
because
otherwise,
you might see god,
every sorrow and joy that you miss,
and think of me
as quite disgusting.

I Traveled

I traveled a long distance
to get away from you:

Over the hills and through the meadows,
into flame and under the earth,
to new continents and wild dreams.

But you're still here,
aren't you?

On Being A Writer

On being a writer:
If you can't sleep, you write.
If you're angry, you write.
If you're in love, you write.
If you are on fire, you put out the fire, and you write.
If the world is about to end, you write.
If you are dead, you write.
If time and space cease to exist,
you write.

Two Indifferent People Meet

Two indifferent people meet.
Everything becomes very difficult.

Just Take A Deep Breath

As you starve to death,
are burned alive,
the guillotine lops off your head,
you are incinerated by a nuclear blast,

just take a deep breath,
you'll feel better.

Bright

Bright!
Bright like the cloudy falling sunset
red orange purple pink and darkening blue blue blue.

Brighter still on the peacock's tail.

Bright bright bright
moon light!

Bright like a bonfire burning ablaze in a smoldering glow.

Bright like fireworks boom booming.

Brighter and brighter and brighter
like grass green meadows of birds chirping.

Bright! Bright and yet brighter still!
Bright like the crescendo of songs sung by an ocean choir.

Bright like a hundred candles whispering flickering.

Bright like hope.

You are bright.

"Divine Intervention"

Today a duck visited me,
flying in alone from the south.

He stared directly at me before
taking a step forward
and making one of those
sounds that ducks make.

I had to wonder if
he was in fact the Buddha
attempting to bless me
with divine wisdom.
Or maybe he was
some spiritual apparition.

But you see, I have a fear
of wild and even domesticated
animals approaching me
unannounced, especially
when they do not
speak my language.

I stood up,
he paused.

I gathered my things
And he walked a full
circle around
the tree I had been laying against.

The duck looked at me
one last time
before flying
back south.

I have my regrets, but

maybe you just wanted food.

I definitely wasn't going to give you any food
unless you told me secrets about the universe.

Overall if you were some spiritual manifestation,
you didn't do a great job at it.

So, until next time, "divine intervention"
get your shit together.

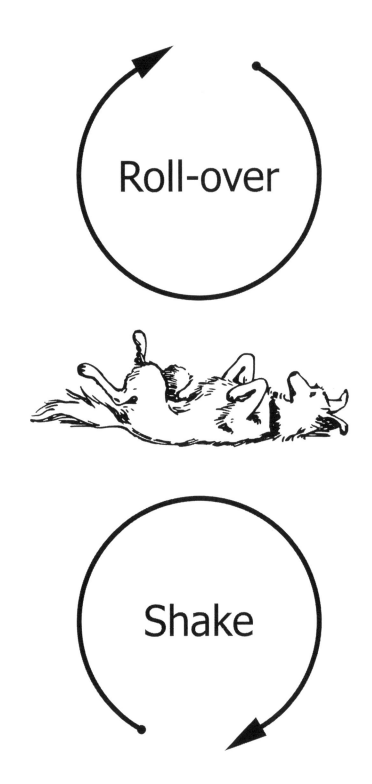

Roll-over

Shake

We Kept The Lie Alive

We kept the lie alive
by feeding it
macaroons, grapes,
chocolate cake with strawberries on top, and
very fine wines.

We taught the lie to sit, shake, and roll over.

The lie learned how to trust us.

And at the end of every night we would say,
good little lie,
yes you are.

Foreshadowing

I know that you're not going to listen to me
but
at least my unsolicited advice
can act as
foreshadowing
for your shitty life ahead.

Where Is The Queen?

I'm wandering aimlessly
through the night,
mingling with a glow of stars
as I wonder where the
queen is.

Maybe she decided to dance in
some other universe tonight,

Maybe there is no queen, only
a fixated fascination,

or maybe,
just maybe,
I
am the queen.

Exchange

We exchanged
a pleasant round of banter
before you
tried cutting
off my head
and oh how I ran,
savoring the sweet words that
meant,
perhaps,
finally,
I had met a friend.

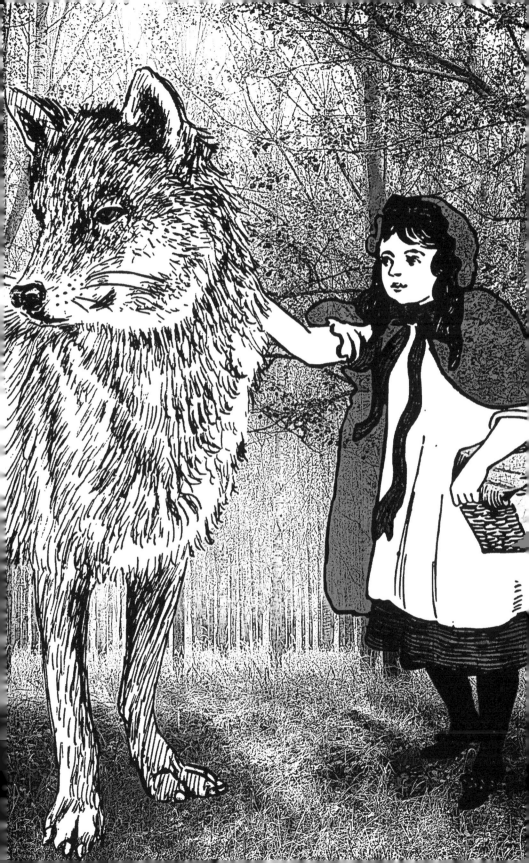

Shit List

I'm looking for people
to go on my shit list.
It can fit
an infinite number of you
lousy fuckers,
so don't be shy,
sign up today.

You get free glares for life
and terrible gossip.
What's not to love?

Writing Poetry

Writing poetry
is like
making a wound
clot with blood,
and whenever
I see you,
I need
to write a poem.

Your Name

You drank
three glasses at the watering hole
like a curious crow
and perhaps we met once upon a time
and perhaps your colors mingle with mine
and perhaps you know god and that fire,
but,
your name
your name
your name
I cannot remember.

Black Sock

Every day I sit by a tree,
and by the tree is always a sad black sock.

The sock and I listen to
trains choo-chooing and cars vroom vrooming.

I think we are very much alike.
The sock tells me things about the universe and
I write them down.
I tell the sock about my troubles,
and the sock doesn't care.

I'm not friends with the sock,
I actually find the sock to be
quite disgusting and gross.
It shouldn't be there at all,
but I'm too apathetic to do anything about it.

You Know

You know,
the button dropped
gold grounded
by time-lapsed historians
paving over ghosts
of the forest.

Do you hear
the whispers of this town?

The cats tell tales
nestled among a rich spring bloom,
The dog, the grandmother, who is next?
Death is rich and cursed with purple.

There's been a murder
of the mind,
Just look at the children
grasping for roots
in lucid dreams.

Don't you see you need seeds?

Figs And Wasps

As my home burned to the ground,
she handed me a giant bag of green figs,
and I wondered if I could be in love
like figs and wasps are.

Doppelganger

You meet people who are reiterations of your past,
the ghosts,
and you already know how it will play out
but maybe there is hope in this hilarious situation.

Things are a little different this time;
you're wearing a new shirt, practice meditation, and know how to cook
spaghetti al dente.

A doppelganger who knows nothing about that past, that person, their
other.

This is a fresh start,
but I have a feeling
it's bound to catch on fire again.

Tea And Machines

I finished my tea
and began walking from the heart,
through throngs of jubilant machines
eating
drinking
fucking
carrying out their preordained cacophony.

I walked further,
thinner were the machines
like wolves guarding passageway
to the grand party.

And then came the silence
of stray lights.
Resting were these forgotten machines,
safe and ready for the morning sun.

Visit Me Godzilla

Today I saw an ex-lover,
like a beautiful portrait of a monster
sipping coffee,

and an old acquaintance
I couldn't remember the name of
said a blurry
hello,

and two people I once considered friends
stood by idly exploring
the expanses of possibility,

and sometimes
I just wish that Godzilla
would come and visit me.

Go For It, Dude

I was hesitant to kiss her until
I met with the Grim Reaper
and the sickle of death said,
go for it,
dude,
I'm coming for you soon.

She Asked

She asked
me who I was
but what could I say to that?

Six years ago,
we became so strangely connected.
Do you remember who you were
six years ago?

You're living the dream and I'm in a box
we told each other.

Maybe it's because the cats have been visiting me again;
there on the pathway scurrying skittish into the bramble,
looking distantly forlorn in a window,
and through the front door begging for something more.

Yesterday they tore the beating heart
out of a bird's chest and ate his head.
Perhaps that is how it feels.

There is death creeping closer.
"Sister,
grandmother,
friend,"
it says,
"I will carry you
far beyond the rivers again
where the only love
is from
those small moments
you could have had."

Time is
slipping
and asking how to weave a starry night sky with ocean waves.

You left,
and the cat is meowing.

I Must

Last night the rain poured down in soothing gusts,
a pittering pattering attempting to
form this new season's trust
and producing a very fine musk.

But it is for the gods and demons that I lust,
so I must
I must
I must
find you in this quickly fading dust.

Entropy

Oh behold the dazzling colors and smells of flowers,
the marble sidewalks and bronze streetlamps,
the elegant silverware and fancy dishes,
the painted strokes of a masterpiece,
the love at first sight,
those muscles,
the curves!

Yeah, um,
hi, my name is entropy
and I'm coming for you
all.

Five Seconds To Tea

Time is not on my side
with death swinging that scythe
to the rhythm of random seconds.

I walk in and hope is there,
looking me in the face.

I like to think that she has a
secret crush on the
person I could be.

The room is uncomfortably crowded
and in the corner
is one of those other people.

She looks a little older
and I wonder how soon she'll die,

but she's not dead right now

so I leave,
without any love,
or tea.

I had been attempting
to change my life for the better,
but the spaces I emptied
became filled with shadows of
the past
and pulled me under.

Outside I'm standing in a junkyard,
waist deep in the refuse and rubble

of kingdom come.

The heap
is bountiful,
and sometimes beautiful,
but any gems are buried deep.

I see a demigod
walking by
but she is sick
and can't last much longer.

It's fly or fall, so who would want to rule over garbage?

The seconds run past,
but maybe next time there will be
tea,
hope,

love.

I Wish I Could Go Back

She sat there in the sunlight
looking like the ghost of love,
ethereal and lost in memories,
with hands griping a steaming mug
and releasing a heavy sigh.

She said, so slowly,
with the delicacy of a field of flowers,
and the sadness of the waning moon,
"I wish I could go back."

Leak

There is a hole in my head,
and each time I lay down
a part of my past leaks out
staining my sheets
the colors of
anger, anxiety, and that goddamned ghost.

Perhaps I drink wine in hopes
of finding a cork that fits.

Flowers Or The Worst Day

When you find yourself at the
very bottom of everything
and look patiently, carefully, willingly,
in the dark you will see a small god
smiling.
Yes she will lift you up and carry what remains
right to the Emperor himself
and face to face with such power
you can take flowers or
the worst day of your life.
It's your choice at the bottom of everything.

Restless Night With You

I've enjoyed sleeping with birds and tigers, bears and snakes,
but laying down with you is a restless night
as we bite and gnaw on what we hope is true.

Darkness

I fled the campfire of
strangely happy people
to go be alone with the ocean waves.
I met a shadow there who showed me fireflies in the sand, then
stood watching the darkness.
And in that moment she came for me,
falling from the sky,
the shooting star landing in my mind.

Small

I hid in the bushes,
black as night
with distant worlds beaming into my mind.
Do not see, speak, smell, think, feel, taste, hear.
Each has become an anger crushing hearts.
Small small small.
I will be safe
and survive.

Rest

I go to bed dull, cracking, fading into darkness,
I wake up shiny shiny new.

The Colors Of Life

The emperor gave me these flowers,
so I must live,
I must fly,
ready to show you
the colors of life.

Who Do You Think Won?

A duck visited me,
A tree branch fell on my head,
bugs crawled all over.

Let me just dig a hole in this ground and
lay there quietly and sad for five million years.

On a sign it will read:
here the man spoke to God,
ready with a knife to strike.

Who do you think won?

Fail Hard To Regain

I wonder if you played that
album over and over again
to give me a soundtrack
to mourn you by.

Six years later I'm driving down the highway
noticing all of our favorite corporations
singing loudly about themselves.

Why, there was Micky D's, Ford Motors, Direct TV, Safeway,
and who could get forget WAL-MART?
It was a never-ending parade of monumental making.

And I wondered if those trees you saved
were still glad to be alive
or screaming.

Time is fleeting, and haunted by these hopeful decisions that turn sour.
You are a lemon of my life.
But I think,
I still love you

Even as I fail hard to regain.

Introduction

I am not sure if I have properly introduced myself,
I am something that only the trees know about.

Life For Possibility

We used up the earth
like teenage lovers
use up each other,
finding beauty for a moment before the fallout.

Yes if we were kind we
might have lived longer,
but we would never have known
this possibility
we sometimes cherish with wonder.

35%

The doctors were performing
surgery on the street again,
cutting great swaths of concrete out to
expose strange pipes and wires I
didn't understand the meaning of.

The city was sick again.

On my way I saw a friend,
someone who could be a friend one day,
and another person who didn't really have the time.
It was a procession of familiar faces walking
to unknown destinations,
but I traveled upstream,
finding myself in a room full of frankincense and
with a woman whose tattoo read "35%".

I wonder if the doctors had anything to do with her,
but I couldn't understand what 35% was about.
So I said not to be surprised if
I was gone in the morning, and she responded,
"that's what cats normally do."

I stole away into the night,
leaving behind 35% of everything.
Good thing broken hearts don't die.
I want nothing to do with those doctors,
but I hope they fix this city soon.

Everywhere A Fucking Fuck

One fuck, two fuck, three fuck, four!
Here a fuck, there a fuck,
everywhere a fucking fuck.

There were fucks coming through the windows,
down the chimney.

Fucks on the news, fucks in the mailbox
Fuck they were coming out my ears, mouth, and nose!

It was a fucking fuckery if I'd ever seen one.

The fucks had won,
loud and boisterous.
I couldn't think,
I couldn't sleep,
and I couldn't take it any longer.

Fuck you
Fuck you
Fuck you!
I said,

to the fucks on my toast,
to the fucks in my friends,
to the fucks atop my house.

I listened close to those fucks
and devised a plan to defuckify
my life.

I started by sweeping out the
fucking dust bunnies hiding in my room,

moved to the kitchen and chopped up a salad
to cleanse the fucks in my gut,

called up my friend and apologized
for my fucking words,

applied to a new job while
telling my boss to fuck off,

ran out a few fucks
in my first marathon,

and finished the final fucking blow
with a rigorous course in
mindfuck meditation mastery.

Where a fuck?
Not here, you fucks.

You Are

Are the leaves soil?
The leaves are soil, and the soil is the tree,
and the tree is you.

You are
soil,
leaves,
the tree.

Glaring Compliment

I hate
your beauty,
so the deeper I glare at you,
the more beautiful
you'll know you are.

It's a compliment.

One Memory Of Love

One memory of love meeting the present,
beautifully.

Everyone faded away and there
was just
the forest
and coyote,
the soothing calm
and monster,
the knowledge that your embrace was
a momentary joy
and the roots,
the fangs,

They want me back badly.

Light And Dark

You are a light with
a darkness and
I am a darkness with
a light.
Our love is mildly deadly
and equally exciting.

Man Bird

I could have sworn
I heard a man up this tree,
hoping maybe he was like me,
jealous of those birds
flying so free.

Her Whispered Words

Her whispered words glowing with the warmth of fire
lit a match under the frozen ways,
set me ablaze
and I promised to diligently grow the flame
one person every day.

Thank You

I had a dream
and you were there.

Thank you for being here.

About The Author

Sage Liskey is an Oregon-born writer, artist, designer, and activist. He is the founder of the Rad Cat Press and author of zines and books covering mental health, activism, community, sustainability, and poetry. Learn more at www.sageliskey.com or follow him on Instagram and Facebook.

Made in the USA
Monee, IL
23 May 2023

34299002R00109